The New York School

A CULTURAL RECKONING

BY DORE ASHTON

UNIVERSITY OF CALIFORNIA PRESS

Berkeley · Los Angeles · Oxford

University of California Press
Berkeley and Los Angeles, California
University of California Press, Ltd.
Oxford, England

Originally published in England under the title *The Life and Times of the New York School: American Painting in the Twentieth Century*.

First published in 1973 by The Viking Press.

Reprinted by arrangement with Viking Penguin, a division of Penguin Books USA Inc.

Library of Congress Cataloging-in-Publication Data

Ashton, Dore.
 [Life and times of the New York school]
 The New York school : a cultural reckoning / by Dore Ashton.
 p. cm.
 Reprint. Originally published under title: The life and times of the New York school.
 Includes bibliographical references and index.
 ISBN 0-520-08107-2 (cl). — ISBN 0-520-08106-4 (pbk.)
 1. New York school of art. 2. Arts, Modern—20th century—United States.
I. Title.
NX504.A87 1992
700'.9747'10904—dc20 92-11669
 CIP

Printed in the United States of America

9 8 7 6 5 4 3 2

The paper used in this publication meets the minimum requirements of American National Standard for Information Sciences—Permanence of Paper for Printed Library Materials, ANSI Z39.48-1984.

ACKNOWLEDGMENT
Random House, Inc.: From 'Age of Anxiety' from *Age of Anxiety* by W. H. Auden, Copyright 1946 by W. H. Auden. From 'September 1, 1939' from *The Collected Poetry of W. H. Auden*, Copyright 1940 by W. H. Auden. From *Man's Hope* by André Malraux, Copyright 1938 by Random House, Inc.